T0150375

Nature Illuminated

Miserere mei deus secundum magnam misericordiam tuam; et secundū multitudinem miserationum tuarum. dele iniquitatem meam. Amplius laua me ab iniquitate'mea; & à peccato meo munda me. Quoniam iniquitatem meam ego conosco, et peccatum meum contra me est semper. Tibi soli peccaui et malum contra te'feci; ut iustificeris in sermonibus tuis. et uincas cum iudicaris Ecce'enim in iniquitatibus conceptus sum; et in peccatis concepit me'mater mea. Ecce'enim ueritatem dilexisti, in certa et occulta sapientia'tuæ'manifestasti mihi. Asperges me'domine'hyssopo et mundabor: lauabis me'& super niuem deʼalbabor. Auditui meo dabis gaudium. et lætitiam; et exultabunt ossa humiliata. Auerte'faciem tuam a peccatis meis: et omnes iniquitates meas de'le'. Cor mundum crea in me deus; et spiritum rectum innoua &

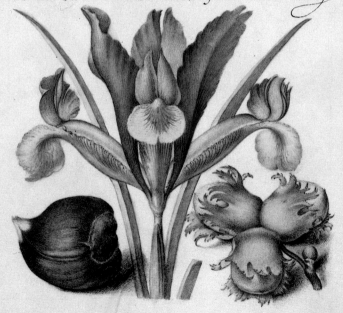

Nature Illuminated

FLORA AND FAUNA
FROM THE COURT OF THE
EMPEROR RUDOLF II

Lee Hendrix and
Thea Vignau-Wilberg

THE J. PAUL GETTY MUSEUM
LOS ANGELES

The illustrations in this book have been selected from
Mira calligraphiae monumenta,
first published by the J. Paul Getty Museum
and Thames & Hudson, Ltd. in 1992.
The texts have been adapted from
the same volume.

© 1997 J. Paul Getty Trust
First edition 1997
Sixth printing

Published by the J. Paul Getty Museum, Los Angeles
Getty Publications
1200 Getty Center Drive, Suite 500
Los Angeles, California 90049-1682
www.getty.edu/publications

Distributed in the United States and Canada by
the University of Chicago Press
Distributed outside of the United States and Canada
by Yale University Press, London

Printed and bound in China by Toppan Leefung Printing Ltd.

ISBN 978-0-89236-472-5
Library of Congress Control Number: 97199200

On the front cover:
Folio 40 (Imaginary butterfly, snakeshead, English walnut and sweet cherry)

On the frontispiece:
Folio 52 (Spanish chestnut, English iris and European filbert)

Introduction

THE miniatures reproduced here are from one of the most precious books of the European Renaissance, the *Mira calligraphiae monumenta* (the *Model Book of Calligraphy*) of Rudolf II. It is the work of two people who never actually met, and its origins are curious and complex.

In 1561–62 the master calligrapher Georg Bocskay, imperial secretary to the Holy Roman Emperor Ferdinand I, created a Model Book of Calligraphy, consisting of 128 folios and demonstrating a vast selection of contemporary and historical scripts. It was intended as proof of his own pre-eminence among scribes and was a work of exceptional visual splendor, being written on the finest white vellum and lavishly embellished with gold and silver. Bocskay was born in Croatia, then part of Hungary. Clearly an outstandingly gifted master of his art, he was a valued, and highly paid, member of the Imperial court at Vienna, where he was described as 'scribe,' 'secretary' and 'court historian' and where his *Model Book of Calligraphy* was written. He also served Ferdinand's successor Maximilian II, and died in 1575.

More than fifteen years after Bocskay's death, Ferdinand I's grandson, Emperor Rudolf II, commissioned Europe's last great illuminator, Joris Hoefnagel (1542–?1601), to illustrate the calligrapher's work. Hoefnagel was a man of immense learning and devised an ingenious figural response to Bocskay's scripts. Marshalling all the resources of pictorial illusionism, he sought to demonstrate the superior power of images over written words. His illuminations present a world of flowers, insects, fruit, small animals, and other forms of natural minutiae as extensive in its own way as Bocskay's collection of scripts.

principally for medicinal or other utilitarian purposes, in favor of an aesthetic and natural historical appreciation of plants, which placed emphasis on the beautiful and the rare. This formalistic and visually oriented interest in natural variety for its own sake was a manifestation of the larger effort to collect and classify all of nature's production that dominated sixteenth-century natural history.

The *Model Book of Calligraphy* stands at an art historical crossroad. It constitutes one of the last important monuments in the grand tradition of medieval European manuscript illumination. In addition to its meticulous studies of flora and fauna, it points directly to the emergence of floral still life painting, an essentially new artistic genre of the seventeenth century, whose early centers of production and collecting were the Netherlands and the court of Rudolf II at Prague. Bocskay's achievement bears an analogous relationship to the history of Western writing. Produced at a time when printed books had almost totally replaced manuscripts, it celebrates the function of the handwritten book as the principal preserver and disseminator of knowledge while also showing the concern with self-expression that would dominate the uses of script from the sixteenth century on.

Captions to the plates on p. 57 ff.

um appropinquaret dominus
Hierusalem: videns Ciuitatē
fleuit super illam, et dixit: quia
si cognouisses et tu: quia venient dies in te, et circundabunt te inimici
tui vallo: et circundabunt te: et co
angustabunt te undique: et ad terram prosternent te: eo quod non co
gnouisti tempus visitationis tuę.

Loria enim parentum natis pre
clarus est, magnificulque thesa
urus. Ornatus quidam est temperantia,
et a voluptatibus abstinentia. Vir sapi
ens ornat munus suum suauitate ser=

monis. Volucres associant se sui
similibus, ita ueritas adiungit
se his, qui obediunt illi. Mul
ti ceciderunt per aciem.
gladij sed non tam.
multi quàm per.
virulentas lin
guas.

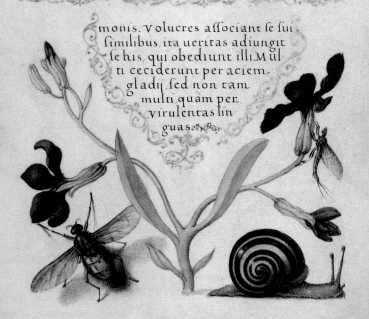

Er amorem Dei amor proximi gignitur:?
per amorem proximi amor Dei nutritur.
Agros, ? vrbes sapientia ? nauem gubernat. Gau
dio afficitur ille, qui discendo, et contemplando.
ipsa intelligentia delectatur. Nemini est ignoran
dum animam hominis immortalem esse, ? ab inte
ritu liberam.

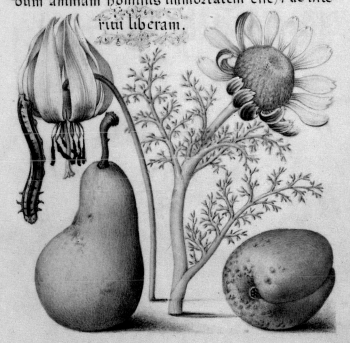

B Eati quorum remissæ sunt iniquitates, et quorum tecta sunt peccata. Beatus vir cui
non imputauit dominus peccatum nec est in spiritu eius dolus. Quoniam
tacui inueterauerunt ossa mea, dum clamarem tota die. Quoniam die ac noc
te grauata est super me manus tua, conuersus sum in erumna mea dum configitur
spina. Delictum meum cognitum tibi feci, et iniustitiam meam non abscondi. Dixi con
fitebor aduersum me in iustitiam meam domino, et tu remisisti impietatem peccati
mei. Pro hac orabit ad te omnis sanctus, in tempore opportuno. Verumtamen in diluuio
Aquarum multarum: ad eum non approximabunt. Tu es refugium meum a tribulatio
ne quæ circundedit me: exultatio mea erue me a circundantibus me. Intellectum
tibi dabo et instruam te in uia hac qua gradieris: firmabo super te oculos meos.
Nolite fieri sicut equus: et mulus quibus. Non est intellectus. In chamo et freno ma
xillas eorum constringe: qui non approximant ad te. Multa flagella peccato
ris: sperantes autem in domino misericordia circundabit. Lætamini in domino
et exultate iusti: et gloriamini omnes recti corde.

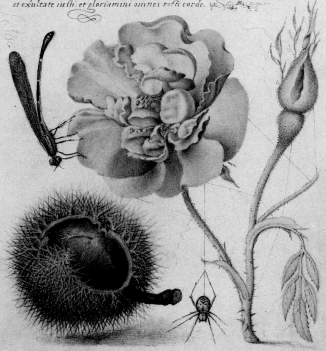

fflictus sum, et humiliatus sum nimis, rugieba
à gemitu Cordis mei. Domine ante te omne
desiderium meum, et gemitus meus à te non
est absconditus. Cor meum conturbatum est, dereliqt
me uirtus mea, & lumen oculorum meorum, & ip-
sum non est mecum. Amici mei & proximi mei, ad
uersum me appropinquauerunt, et steterunt, &
qui inquirebant mala mihi locuti sunt uanitates. &

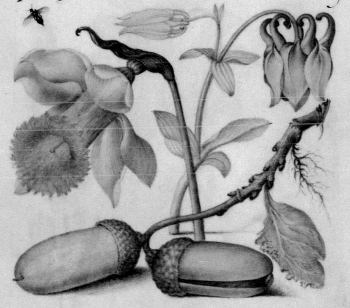

Quoniam iniquitates meæ super greße sunt caput meum, & sicut onus
graue grauate sunt super me. Putruerunt & currupte sunt
cicatrices meæ: a facie insipientiæ Meæ. miser factus sum & cur
vatus sum usque in finem tota die contristatus ingrediebar. Quo
niam lumbi mei impleti sunt illusionibus: & non est sanitas &

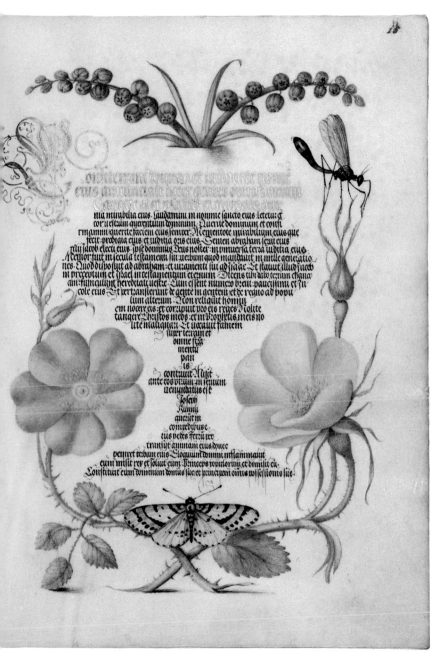

mia mirabilia eius. Laudamini in nomine sancto eius. Leteta: et
cor uestrum querentium dominum. Querite dominum et confir-
mamini querite faciem eius semper. Mementote mirabilium eius que
fecit: prodigia eius, et iudicia oris eius. Semen abraham serui eius:
filii iacob electi eius. Ipse dominus deus noster: in uniuersa terra iudicia eius.
Memor fuit in secula testamenti sui: uerbum quod mandauit in mille generatio-
nes. Quod disposuit ad abraham: et iuramenti sui ad ysaac. Et statuit illud iacob
in preceptum: et israel in testamentum eternum. Dicens tibi dabo terram chana-
am: funiculum hereditatis uestre. Cum essent numero breui: paucissimi et in-
cole eius. Et pertransierunt de gente in gentem: et de regno ad popu-
lum alterum. Non reliquit homi-
nem nocere eis: et corripuit pro eis reges. Nolite
tangere christos meos: et in prophetis meis no-
lite malignari. Et uocauit famem
super terram: et
omne firma-
mentum
pani-
s
contriuit. Misit
ante eos uirum: in seruum
uenundatus est
ioseph.
Humi-
liauerunt in
compedibus
eius pedes: ferrum per-
transiit animam eius. Donec
ueniret uerbum eius. Eloquium domini inflammauit
eum misit rex et soluit eum. Princeps populorum: et dimisit eum.
Constituit eum dominum domus sue: et principem omnis possessionis sue.

uærendum est igitur quid ipsa lepra significet. Non enim sanati:

sed mundati dicuntur: qui ea caruerunt. Colori quippe uitium est:

non ualetudini: aut integritati sensuum atque membrorum.

prosi ergo non absurde intelliguntur: qui scientiam uere fidei non

habentes, et cætera.

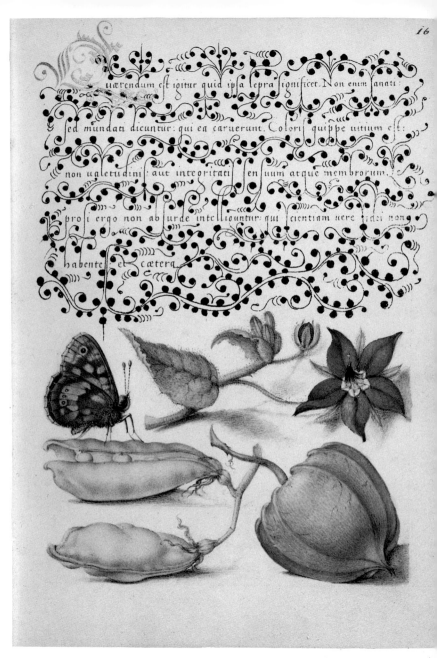

Domine non est exaltatum cor meum, neqz elati sunt oculi mei, Neque ambulauj In magnis, neqz In mirabilibus Super me. Si non humili ter sentiebam, sed exaltauj Animam meam. Sicut Ablatentus est super Ma trem suam, Ita retributio in anima mea. Speret Israel in Domino, ex hoc nunc, & vsqz in seculum. Memento salutis Auctor, Quod Nostri quondam corporis, Ex illibata virginis Nascendo formam sumpseris. Maria ma ter gratia, Mater misericordia, Tu nos ab hoste protege. Et hora mortis suscipe. Gloria tibi domine qui natus es de virgine, Cum patre Et san cto spiritu in sempiterna saecula. Amen. Quia Apud Dominum misericor dia, Et copiosa Apud Eum Redemptio. Et ipse Redimet Israel, ex &c

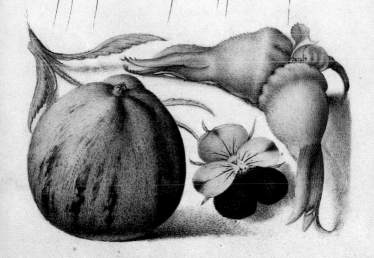

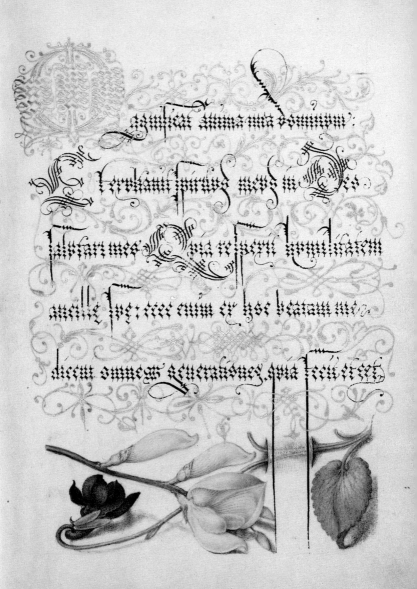

agnificat anima mea dominum:

Et exultauit spiritus meus in Deo

salutari meo. Quia respexit humilitatem

ancille sue: ecce enim ex hoc beatam me

dicent omnes generationes, quia fecit mihi

uic quasi proximo lumine humanitati cobulatur. quæ ta Do

minicæ sententiæ Diffinitione Distinguitur: si In pau

peres et Debiles conferatur. Nam hospitalem esse

remuneratur. affectus Auaritiæ. et postremo Qua

li emeritæ militiæ. si Ro.contemnen Darum stipen Dium.

ostis Nenobis in
pio Christi venit
quo vires non exipifier
tala quiragia dat ce
lestin et ist.

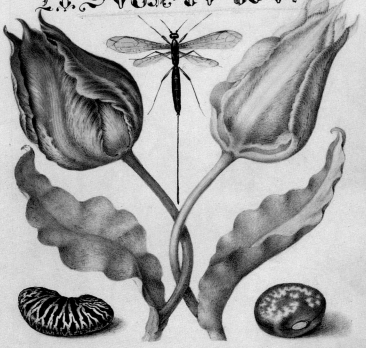

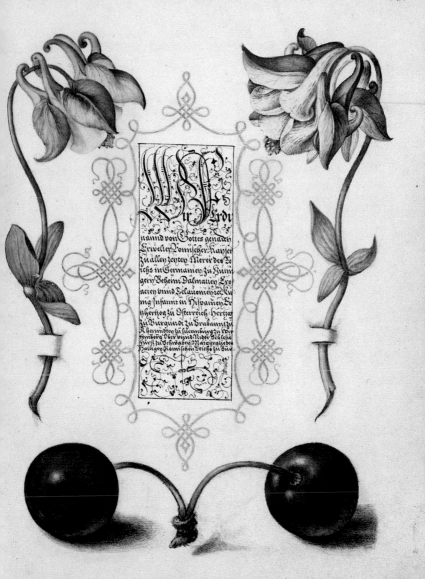

d cœnam Agni prouidi & stolis albis candidi: post transitum Maris rubri Christo canamus Principi. Cuius corpus sanctissimum in Ara crucis torridum: cruore eius Roseo gustando uiuimus deo. Protecti paschæ uespere, ac deuastante Angelo: erepti de durissimo Pharaonis Imperio. Iam Pascha nostrum Christus est qui immolatus Agnus est: sinceritatis azyma caro eius oblata est. O uere digna hostia per quam fracta sunt tartara, redempta plebs captiuata reddita uitæ præmia. Cum surgit Christus tumulo uictor redit de barathro: tyrannum trudens uinculo et reserans paradisum. Quæsumus author Oium &c In hoc Paschali gaudio: ab omni mortis impetu tuum defende populum Gloria tibi Domine qui surrexisti a mortuis: cum patre et cœt &c

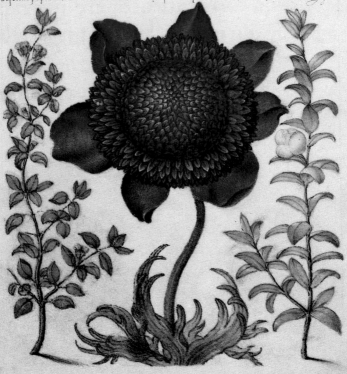

HESUCORONÆ CELSIOR ATUE
RITHÆ SUBLIMIOR: QUI CON
HÆRENTI SERUULLO RÆODIS
PÆRENNÆ PRÆMIUM OH SUPPLI
CÆNTI ÆÆTUE: OBTÆNTU HUÆUS
OPTIMI REMISSIONEM ARIMINU
RUMPÆNDO NEXUM, UINÆULI:

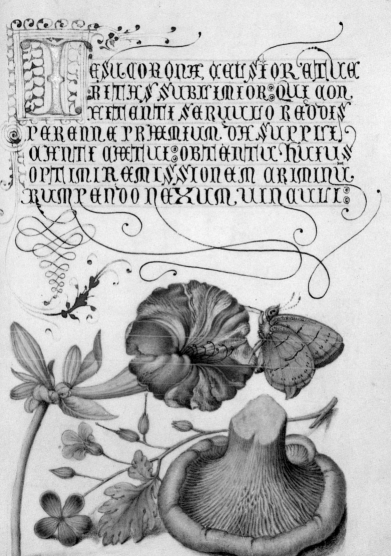

mnipotens et ad misericors deus qui cœlos cœlox qz virtutes Mirabili di
spensatione regis et omnia iusto iudicio discernis. Qui de uiuis
et electis lapidibus æternum Lordis habitaculum tuæ maiesta
ti Dedicasti: Pe per sancte et indiuiduæ trinitatis nomen z Confessionem
omnium fidelium Ego miserimus immundis labijs exorare præsumo Ut
per intercessiones et Merita sanctox quorum hodie festa celebramus,
Vel quox hic sacræ pausant Reliquiæ mei cordis tenebras, lumine tuæ
indulgentiæ illustrare, et pectoris mei duritiam tuo suaui iugo edomare di
gneris. Ne despicias in me misero, creatura tua. Omnipotens Deus opus
manuum tuarum, Sed in hoc templo, Luius hodie diem dedicationis cele
bramus: exaudi præces mei indigni famuli tui, ne per innumeras facino
rum meorum Ruinas mihi misero, illa et cętera

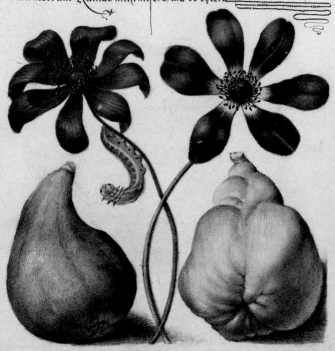

interrogauit Jesum unus ex phariseis legis doctor ten
tans eum, magister, quod est mandatum magnum in le
ge. Magistrum uocat cuius non uult esse discipulus,
simplicissimus interrogator. Et malignissimus insi
diator: de magno mandato interrogat qui nec mini
mum obseruat. Ille eam debet et cœtera.

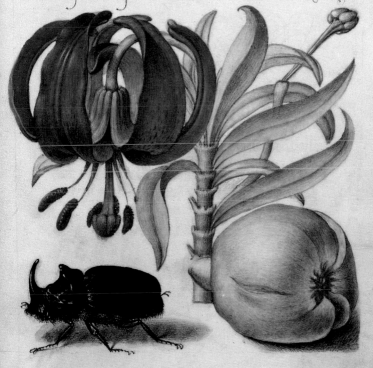

oltacquàm dominum inquit patri
anque derelinquens, peregre profe
ctus est in regionem longinquam;
Quid est longinquius quàm
moribus separari, studiis disere
tum esse non ieritis: et quasi et cet

ADESTO DOMINE
FAMVLIS TVIS ET
PERPETVAM BENI
GNITATEM LARGI
REPOSCENTIBVS
VT HIIS QVI TE AVC
TORE ET GVBERNA
TORE ET
CET

Omine exaudi Orationem meam: et clamor meus ad te Veniat. Non auer
ras faciem tuam a me, in quacunque die tribulor inclina ad me Au
rem tuam. In quacunque die inuocauero te: uelociter exaudi me. Quia defecerut
sicut fumus dies mei: & ossa mea sicut cremium aruerunt. Percussus sum Vt
fenum: et aruit cor meum quia oblitus sum comedere panem meum: A uoce
gemitus mei adhesit os meum carni meæ. Similis factus sum pellicano solitu
dinis: factus sum sicut nicticorax in domicilio. Vigilaui, & factus sum sicut pas
ser solitarius in tecto. Tota die exprobrabant mihi inimici mei: & qui laudabat
me aduersum me iurabant. Quia cinerem tanquam panem manducabam. &
poculum meum cum fletu miscebam. A facie iræ indignationis tuæ: quia

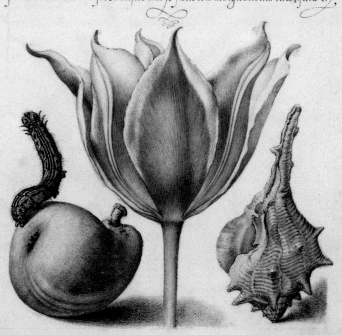

A D TE LEVAVI OCVLOS MEOS
QVI HABITAS IN CÆLIS ECCE SI
CVT OCVLI SERVORVM IN MA
NIBVS DOMINORVM SVORVM
SICVT OCVLI ANCILLA IN MA
NIBVS DOMINA SVA ET CÆT.

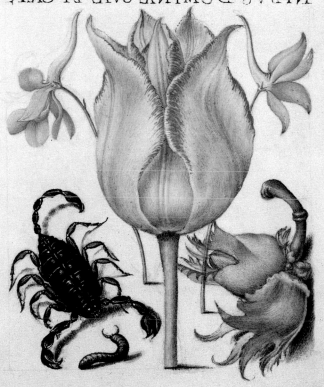

alue regina Mater misericordie, vita dulcedo Et spes nostra salue. Ad te clamamus
exules filij Eua. Ad te suspiramus gementes et flentes in hac lachrymarum valle. Eia er
go aduocata nostra, illos tuos misericordes oculos ad nos conuerte Et Iesum benedictum fruc
tum ventris tui, nobis post hoc exilium ostende. O clemens, O pia, O dulcis Virgo Maria. ora pro
nobis sancta dei genetrix vt digni efficiamur promissionibus Christi. Omnipotens sem
piterne deus qui gloriosæ virginis matris Mariæ corpus et animam vt dignum filij tui ha
biraculum effici mereretur spiritu sancto cooperante præparasti. da vt cuius commemo
ratione lætamur eius pia intercessione, ab instantibus malis, et a morte perpetua libe
remur. Amen:

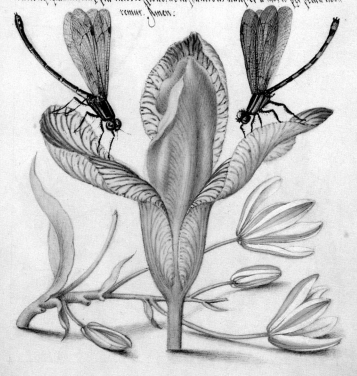

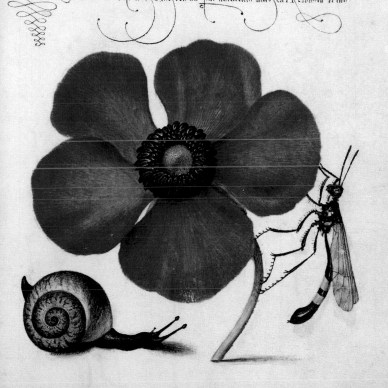

ΕΧΘΡΟΣ ΓΑΡ ΜΟΙ ΚΕΙΝΟΣ ΟΜΩΣ ΑΙΔΑΟ
ΠΥΛΗΣΙΝ, ΟΣ Χ'ΕΤΕΡΟΝ ΜΕΝ ΚΕΥΘΕΙ
ΕΝΙ ΦΡΕΣΙΝ, ΑΛΛΟ ΔΕ ΕΙΠΗ ΟΥΚ ΑΓΑΘ
ΟΝ ΠΟΛΥΚΟΙΡΑΝΙΗ ΕΙΣ ΚΟΙΡΑΝΟΣ ΕΣΤΩ.
ΕΥΧΕΛΡΛΙ, ΠΑΝΤΛΣ ΔΕ ΘΙΩΝ ΧΛΤΕΟ
ΥΣ ΑΝΘΡΩΠΟΙ

Αλεξανδρος ὁ βασιλεὺς ἰδὼν Διογένιν κοιμώμενον ἐν
πίθω ἔφη, πίε μεσ φρενῶν, ὁ δὲ φιλόσοφος, ἀναςὰς ἔφη ὦ
βασιλεῦ μέγιςε, θέλω τύχης ςαλαγμον ἢ φρενῶν πίθον,
ἧς μὴ παρυσης δ'υςυ χρσιν αἱ φρενες,

Ὁ αὐτος ςαριλι ἐπιλαττυσης της μητρος ὀλυμπιαδος,
ἔφη, ἐν παντι τῶ ςιω τρεις μεταμελειας εἶναι.
μιαν μὲν ἐπι τῆ γυναικι πιςευσαι λόγον ἀπορρη-
τον. ἕτερον δὲ πλευσας, ὅπη δυνατον πεςευσαι. την δὲ
τρίτην, ὅτι μιαν ἡμέραν ἀδιαθετος ἔμεινεν.

אַשְׁרֵי

הָאִישׁ אֲשֶׁר לֹא הָלַךְ כַּעֲצַת רְשָׁעִים
וּבְדֶרֶךְ חַטָּאִים לֹא עָמָד וּכְמוֹשַׁךְ לֵצִים
לֹא יָשַׁב: כִּי אִם כְּתוֹרַת יְהוָֹה חֶפְצוֹ
וּכְתוֹרָתוֹ יֶהְגֶּה יוֹמָם וָלַיְלָה: וְהָיָה

B αἰ εἶειος ὁ ἐνεργὸς, τινα ὄντας τὰς ἀωρίσεις ἐκρίνει φυλάττων καὶ ἰσίατα εἰσίαν
ἐξελαύνει ὀσφαδίζει ἐτέα καὶ τὸν θύλακα τῆς ὅλης ἠ ὧν ἄγγελει ἐποδοκρεμ...
καὶ διωθεύσε ἐξίσωσεν ἀμερῆ ἀλλὰ καὶ ὀρεια ζωντωθεῖσιν ὁλίγα ἔτι...

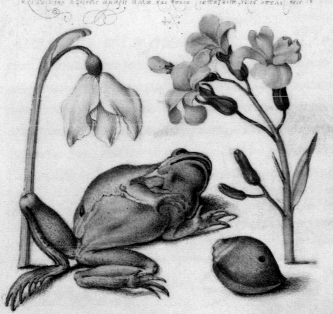

Angularis fundamentus lapis christus missus, qui compage parietis in utroque nectetur: quem sion
sancta suscepit, in quo credens permanet, omnis illa des sacra e ditecta civitas plena modulis in laude
et canore, trinb trinum deum ubicunque cum favore predicat. Hoc in titulo lumine densus exoratus
adueni et elementi bonitate precum nota suscipe: lampan benedictionem hic infunde iugiter. Hic promerean
tur omnes petita acquirere: Q adeous possidere cum sanctis perenniter paradisum introire translatu. In requiem
Aurora lucis rutilat, celum laudibus intonat, mundus exultans iubilat, emens, ferinnt v lulas, cum rex ille
fortissimus mortis confrat eir viribus: pea conculcans tartara soluit a pena miseros, ille qui laudas laude
custoditur sub milite: triumphani pompa nobile uictor, surgit de funere. Solutas eam g centeris et inferni e
loribus: quia surrexit dominus resplendens clamat angelus. et

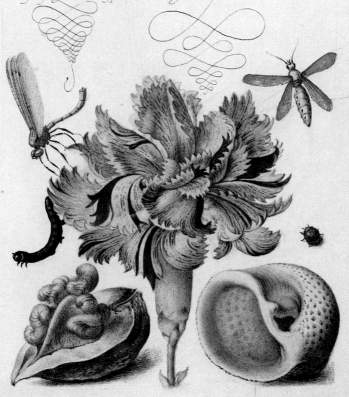

Interueniat pro Nobis quæsumus domine Iesu Christe Apud tuam Clementiam glo
riosissima, Dei genetrix uirgo semper Maria mater tua. Cuius sacratissimam mi
sericordiam in hora passionis et mortis tuæ doloris gladius pertransiuit ò, domi
ne Iesu christe pater dulcissime Rogo te ob Amorem Illius gaudij quod dilecta Mater
tua habuit quando te uidit Et ei apparuisti in illa Sanctissima nocte Pas.ȩ, et per
gaudium quod habuit quando te uidit glorificatum diuinitatis claritate deprecor te quatenus
me illumines septem donis ȩ spiritus sancti, ut tuam uoluntatem adimplere ualeam omnibus
diebus uitæ meæ. O domine Iesu Christe, adoro te in Cruce pendentem et coronam spi
neam in capite portantem, deprecor te ut tua crux liberet me ab angelo percu
tiente, O domine Iesu Christe, adoro te in cruce uulneratum, felle et aceto potatum
deprecor te ut tua uulnera sint remedium animæ meæ. O. domine Iesu christe xℛ.

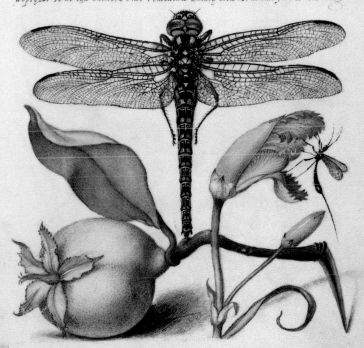

gratam et desiderabilem glorio
sam ac singularem solennitate
hoc est natiuitatem Domini sal
uigtoris fratres dilectissimi de
uotione fidelissima suscepturi totis ui
ribus nos debemus cum ipsius adiu
torio preparare et omnes latebras
anime nostre diligenter aspicere ne
forte sit in nobis aliquid peccatum ꝛc

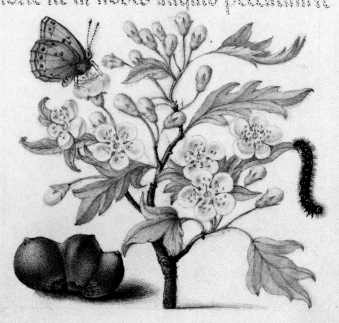

mnipotens sempiterne Deus qui glorio[lae] uirginis
Mariae corpus, et animam, ut dignum filij tui habitaculu[m]
praeparasti: da ut cuius commemoratione laetamur eius
pia intercessione, ab instantibus et a morte perpetua li
beremur: per Dominum nostrum Iesum Christum qui et

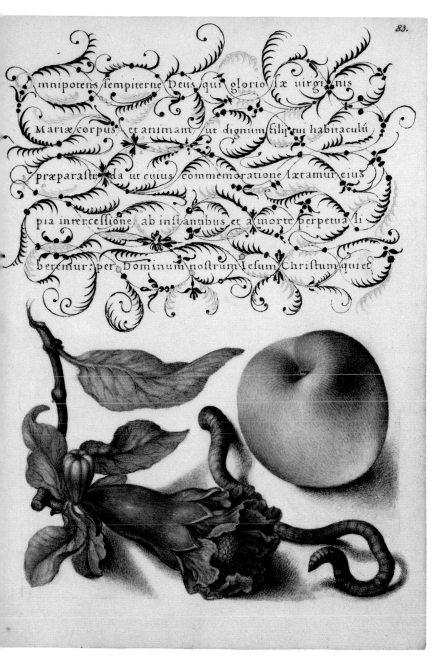

Dem Allerdurchleuchtigisten vnnd
Großmechtigisten Fürsten vnnd herrn herrn
Carln Römschem Kayser zü allen Zeyten / me-
rer des Reichs in Germanien zü Hispanien ꝛc.

Incomparabili Inuictissimatoꝗ ꝛc.

VBI HELENA IBI TROIA.

VBI LAVS IBI LABOR.

Dem allerdurchleuchtigis ten
Großmechtigisten Fürsten vnnd
herrn herrn Carln Römische
Kayser zu allen zeyten/ merer des
Reichs in Germanien zu Casti
lien Arzagon Leon vnd der Sicil

Sacris solemnijs iuncta sint gaudia: Et ex præcordijs
sonent præconia: recedant Vetera noua sint omnia
corda noces Et opera. Noctis recolitur cæna nouissima: qua
Christus creditur: Agnum et alyma: dedisse Fratribus:
iuxta legitima: priscis indulta patribus. Post agnum
Typicum: expletis epulis: corpus Dominicum datum di=
scipulis: sic totum omnibus: quod totum singulis eius fate=
mur manibus: dedit fragilibus: Corporis ferculum: dedit et

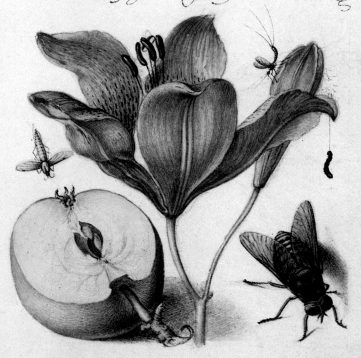

octrina spiritus non curiositatem acuit, Sed chari
tatem accendit. Ipse est christianus, qui in do=
mo sua peregrinum se cognoscit. Nouit Deus mutare
sententiam: Si tu noueris emendare delictum. Vehemen=
ter Ecclesiam Dei destruit meliores laicos esse, quam
clericos. Quocunque tempore non cogitaueris Deum
putate tempus illud amisisse. Pudicitia est virtùs
non solum impetum libidinis coercens, sed et signa co=
hibens. Patria nostra sursum est, ibi hospites non
erimus. Sicut ligat Diabolus, qui peccata conectit:
ita soluit christus qui delicta remittit. Nil ma=
gnum in rebus humanis, nisi animus magna despi=
ciens. &.

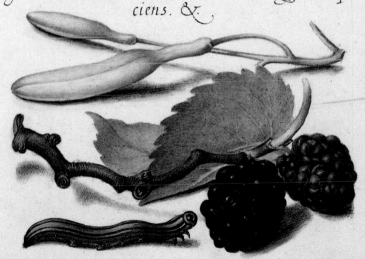

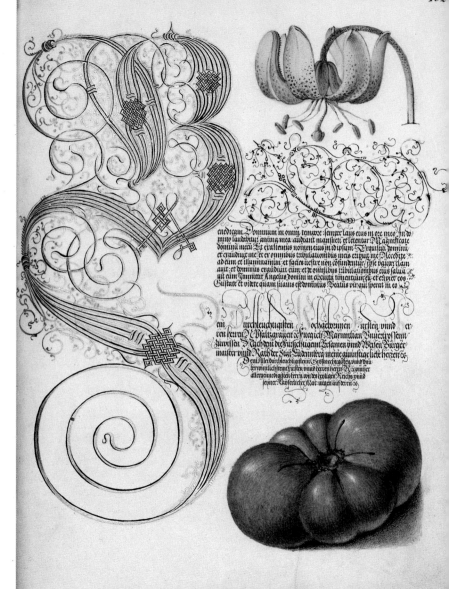

enedicam Dominum in omni tempore: semper laus eius in ore meo. In domino laudabitur: anima mea audiant mansueti et letentur. Magnificate dominum mecum: et exaltemus nomen eius in idipsum. Exquisiui dominum et exaudiuit me: et ex omnibus tribulationibus meis eripuit me. Accedite ad eum et illuminamini: et facies vestre non confundentur. Iste pauper clamauit: et dominus exaudiuit eum: et de omnibus tribulationibus eius saluauit eum. Immittit Angelus domini in circuitu timentium eum: et eruet eos. Gustate et videte quam suauis est dominus. Beatus vir qui sperat in eo.

en durchleuchtigisten hochgebornen furslen vnnd er
ren herren. E Pfaltzgrauen de Reich Maximilian Irwettzyssen
zuwissen. Sich dem die fürsichtigem Ersamen vnnd Weisen Burger
maister vnnd Rath der Stat Ludenberg meine günstige liebe herren. E
Den Aller durchleuchtigisteim Großmechtigisten vnnd Vnu
berwintlichstem Fursten vnnd herren herrn Maximiser
allergenedigisten herrn vnd des heyligen Reichs vnnd
seyner Kaysectichre Mat. wegen auß deren. E

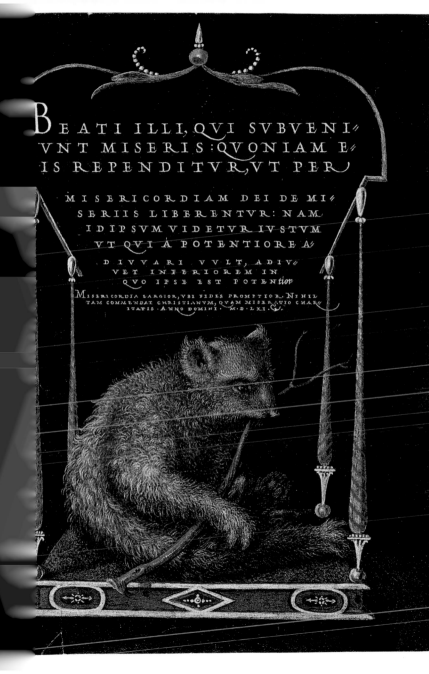

B E A T I I L L I , Q V I S V B V E N I ⁄
V N T M I S E R I S : Q V O N I A M E ⁄
I S R E P E N D I T V R , V T P E R

M I S E R I C O R D I A M D E I D E M I ⁄
S E R I I S L I B E R E N T V R : N A M
I D I P S V M V I D E T V R I V S T V M
V T Q V I A P O T E N T I O R E A ⁄

D I V V A R I V V L T , A D I V ⁄
V E T I N F E R I O R E M I N
Q V O I P S E E S T P O T E N *tior*

MISERICORDIA LARGIOR, VBI FIDES PROMPTIOR. NIHIL
TAM COMMENDAT CHRISTIANVM, QVAM MISERATIO CHAR⁄
ITATIS · ANNO DOMINI · M · D · L X I · ᛜ ·

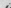

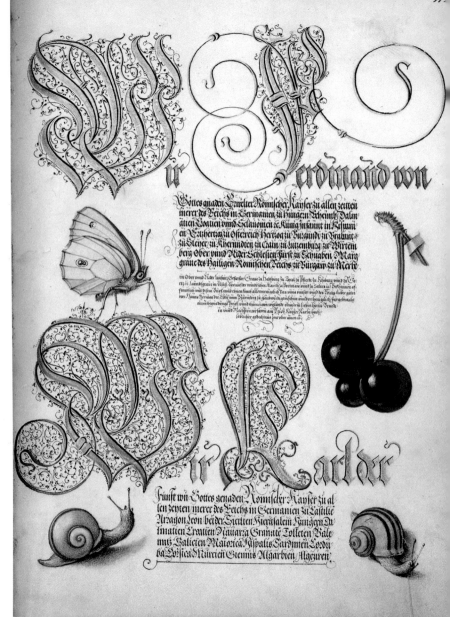

ur Ferdinand von

Gottes gnaden Erwelter Romischer Kayser zu allen zeiten
merer des Reichs in Germanien zu hungen Rheuni Dalm
atien Croatien vnnd Sclauonien 2c. Künig infannt in Hispan
ien Ertzhertzog zu Osterreich Hertzog zu Burgundi zu Grabant
zu Steyer zu Kherundten zu Crain zu Luttenburg zu Wirten
berg Ober vnnd Nider Schlesien Fürst zu Schwaben Marg
graue des Hailigen Romischen Reichs zu Burgaw zu Rerix

rn Ober vnnd Nider lautnig Gefürster Graue zu Dasburg zu Tyrol zu Pferrt zu Kyburg vnnd zu So
ertz zu Lanntsgrafe in Elsass Herrazu der windischen March zu Perten am vnnd zu Salins der Perdienen of
fennlich mit disem Brief vnnd einen fumst allermenigtlich Das vnns vnser vnd der Treuig lieber getre
wer Hanns Perman der Elty von Nürmberg zu haubnig dem schein vnnderthenigtlich furgebrachz
aiten beynebeneg Brief vnnd thumc vnns englandt ainem schen herris Brude
rn vnnd Rechsten zu farm am Reich Kaiser Karls hoch
seligister gedahtnus ime oder ainem dz

Wir Carl der

fiunst von Gottes genaden Romischer Kayser zu al
len zeyten merer des Reichs in Germanien zu Castilie
Arragion Leon beider Sicilien Hierusalem hungern Da
imatien Croatien Nauarra Grainite Tolleten Pale
nitz Galicien Maiorica Hispalis Sardinien Cordu
ba Corsica Murcien Giennis Algarbien Algezuren

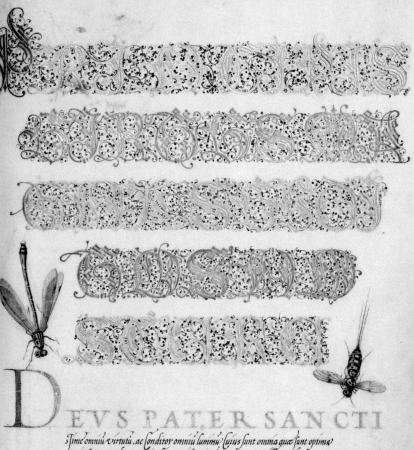

DEVS PATER SANCTI

ſſime omniu̅ virtutu̅, ac ſonditor omniu̅ lumi̅u̅ ſuius ſunt omnia qu̅ ſunt optima
i̅ſere ſecundum multitudine̅ miſeratio̅ni tu̅x, amore̅ illum ardente̅
beatiſſimi tui nomi̅nis, & praeſta i̅ nobis Chriſtiane̅ religionis
augmentum vt tuo diuino auxilio nutriti, ad omnia pie'
tatis ſtudia accedamus & tibi Deo ſoli immori'

TALI PERPETVIS TEM
PORIBVS SERVIRE
VALEAMVS M·
D·LXII
·G·B·

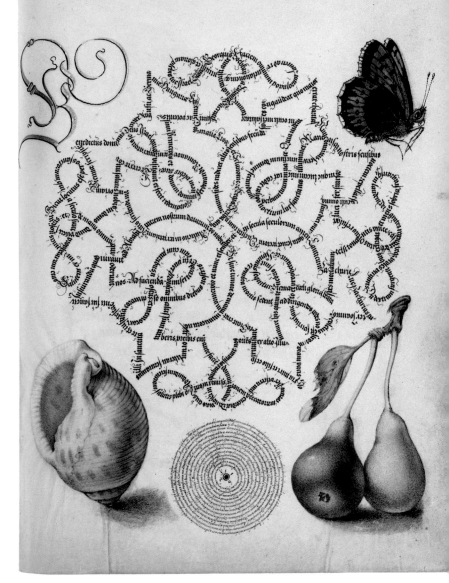

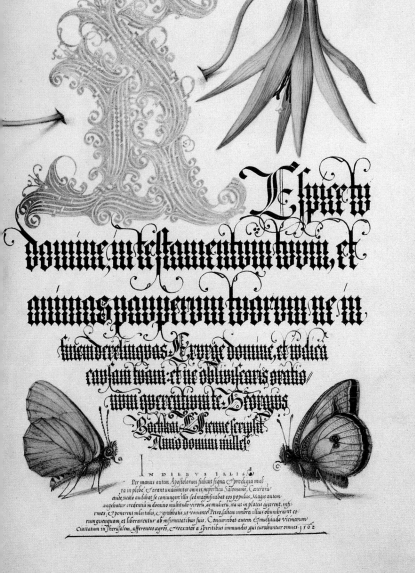

Exaudi
domine, iustitiam meam, et
animas pauperum tuorum ne in
finem derelinquas. Exurge domine, et iudica
causam tuam: et ne obliuiscaris oratio/
num quaerentium te. Georgivs
Bocskai Hungarus scripsit
Anno domini millesi.

In diebvs illis:
Per manus autem Apostolorum fiebant signa & prodigia mul/
ta in plebe. & erant unanimiter omnes in porticu Salomonis. Caeterorum'
aut nemo audebat se coniungere illis sed magnificabat eos populus. Magis autem
augebatur credentiu in domino multitudo virorū, ac mulierū. ita ut in plateas eicerent, infir/
mos, & ponerent in lectulis, & grabbatis, ut veniente Petro saltem umbra illius obumbraret eo
rum quenquam, et liberarentur ab infirmitatibus suis. Concurrebat autem & multitudo vicinarum'
Ciuitatum in Jherusalem, afferentes aegros, & vexatos a spiritibus immundis qui curabantur omnes. 1562

Domine exaudi orationem meam. au
ribus percipe obfecrationem meam
in ueritate tua exaudi me in tua
iuftitia Et non intres in iudi
um cum feruo tuo, quia non iu

tificabitur in conspectu tuo omnis uiuens. Quia per
secutus est inimicus animam meam: humiliauit in
terra uitam meam. Collocauit me in obscuris sicut
mortuos seculi: et anxiatus est super me spiritus me
us, in me turbatū est cor meum. Memor fui dierū antiquorū, meditatus sum
in omnibus operibus tuis, et in factis manuū tuarū meditabar Expandi ma
nus meas ad te: anima mea sicut terra sine aqua tibi. Velociter exaudi me do
mine: defecit spiritus meus. Non auertas faciem tuā a me: et similis ero etc.

The Model Book of Calligraphy

In order to understand Bocskay's *Model Book of Calligraphy* it is necessary to grasp the basic chronology of the emergence of calligraphy, or writing as a fine art, during the sixteenth century. One of the decisive factors in this chronology was the rise of printing, which displaced writing as the primary means of transmitting information.

Before printing arrived in Europe, writing emphasized the preservation of knowledge over its dissemination. Executed on vellum and often embellished with costly gold and silver, writing assumed great palpability and permanence. This was also expressed by the letter forms themselves, ranging from Carolingian minuscule (a classically based, upright, rounded lower-case script), with each individual letter carefully formed and separated from the next, to *textura* (upright, closely packed, Gothic blackletter), the thick, dark strokes of which lent words a physical presence on the page. Printing helped to transform the function of the written word. No longer required to serve as the material embodiment of the text, script evolved into a vehicle for self-expression, deriving its vitality from the hand of the calligrapher.

Also crucial to this development was the spread of writing, which ceased to be regarded primarily as the province of trained scribes and came to be valued as an essential humanistic accomplishment. Just as an educated person was expected to be conversant in many languages, so he or she was required to have mastery over a corresponding number of script forms. Dominant among these was italic, or chancery, script. Rising to prominence during the late fifteenth century in Italy, where it became the favored script of the papal chancery in Rome, italic was based on the clear, upright, round script known as humanist *antiqua*, which, when written quickly, became slanted, attenuated, and cursive. Italic effected the still uncontested wedding of Western handwriting to

line. The kind of line required by italic emphasized dynamism. Writing thus came to constitute the trace of the hand in motion and in so doing, imparted a new sense of life to the written page. Promoting the concept of unique selfhood which lay at the core of the humanistic movement, italic derived authority by evoking the living presence of the writer, accomplishing this by stressing the act of writing. To this end, it was of paramount importance that italic script appear spontaneous and fresh.

In a curious turn of events, printing further contributed to the emergence of writing as an art form, since it was principally through the publication of model books that scribes became widely recognized as distinctive personalities. Notable early contributions came from Tagliente, Arrighi and Palatino.

Georg Bocskay, in *Mira calligraphiae monumenta*, set out to assemble an enormous collection of scripts and to display unparalleled technical wizardry. Pedagogy plays no role in Bocskay's *Model Book*, which is intended solely as a display piece. The script forms are disposed to no overarching order, thus underscoring the fact that the samples are not meant primarily to be read but to be appreciated visually. Most of the texts are prayers, canticles, and psalms, but they also include imperial briefs and other forms of correspondence. The predominant type of script is italic. One finds a range of classic italic hands (fols. 12, 18, 94) that are also furnished with an assortment of initials extending from florid examples written in gold to unadorned Roman capitals. Complementing such correct, restrained demonstrations of italic is the repertoire of flamboyant exhibition scripts to which italic gave rise. Satirizing the stress on linear continuity are the "cut letters" (*lettere tagliate*), in which the upper and lower halves of a line of script seem to be cut loose from one another (fol. 43). Backwards slant, a transgression in italic as it is normally written, becomes a source of amusement (fol. 65).

Second in number to italic in Bocskay's *Model Book* are the various forms of *rotunda* (Italian Gothic) and *antiqua* (a classicizing humanist script based on Carolingian minuscule) (fols. 5, 6). These tend to be among the most sumptuous calligraphic specimens; the

interstices between the lines of script are often filled with dense running vines in black, gold, and silver. Also common is an outlined *rotunda* known as "traced letters" (fol. 1), which are sometimes painted with dots of gold and blue (fol. 81).

The flowering of writing during the sixteenth century was fueled not only by the cultural idealism of the Renaissance humanists but also by the growing bureaucratic substructure in Europe, which required the services of ever larger numbers of secretaries. While italic became the principal secretarial hand in many countries, Gothic blackletter, which evolved into *Fraktur*, and Gothic chancery cursive remained dominant in Germany and the Holy Roman Empire, where they were also featured in writing manuals. As would be expected of a model book made for the emperor by an imperial scribe, Bocskay's codex contains a wide selection of Gothic scripts. Indeed, such a thoroughgoing synthesis of the traditions of Germanic and Italic writing manuals was achieved by no other scribe of the century.

Among the most impressive and numerous samples of *Fraktur* are those from imperial briefs. Folios 85 and 86, which contain salutations to Ferdinand I's brother, Emperor Charles V (r. 1519–56), represent two of the manuscript's imposing black folios. Instead of vellum, they are paper, which was painted white, after which the letters appear to have been drawn in a clear substance resistive of the black ink wash applied over them. Another accomplished demonstration of Germanic Gothic scripts is folio 112, a salutation from Charles V, which features magnificent swashed capitals composed of multiple strokes ending in extended flourishes.

Bocskay further substantiated his implicit claim to universal mastery of his art by a succession of historical, invented, and exhibition hands. Continuing a practice initiated by Tagliente of presenting ancient non-Roman scripts, Bocskay included samples of Greek and Hebrew (fols. 69, 70). Many of the scripts appear to be hybrids, such as that on folio 21, whose thick, black serifs and flourishes appear to have been inspired by mercantile hands.

Exhibition hands other than those already mentioned include mirror writing (fol. 66); a calligram, or text picture whose shape or

layout is determined by its subject (fol. 15); diminishing writing (fol. 106); and micrography, writing too small to be read with the naked eye (fol. 118). Displaying script at its greatest remove from conventional writing, exhibition hands epitomize the drive for virtuosity that dominated calligraphy by the end of the sixteenth century. This focus on virtuosity is in turn the most obvious manifestation of the effort to elevate writing to the status of a fine art that scribes appear to have undertaken in imitation of Renaissance visual artists.

THE ILLUMINATIONS

Hoefnagel's illuminations for Bocskay's *Model Book* are among his latest works, probably done during the second half of the 1590s. The seamless integration of script and image belies the more than thirty-year hiatus separating the two phases of production, and the question of whether the manuscript was originally intended to be illuminated is not easily answered. Bocskay's tendency to inscribe a folio with a single text positioned on the upper portion of the page surface gives the impression that he purposely left space for illuminations. This free space at the bottom of the page, however, is frequently interrupted by descenders or flourishes, pointing to the likelihood that the calligrapher found it aesthetically advantageous to leave copious blank space around his often expansive calligraphic samples. This, coupled with the folios preponderantly given over to calligraphy such as fol. 5, casts further doubt on the likelihood that Bocskay's *Model Book* was originally planned to contain extensive figural embellishment.

Although flowers appear in Hoefnagel's earlier works, they became a major feature of his *œuvre* during the 1590s. His increasingly artistic treatment of flowers coincided with his move in 1591 to Frankfurt, where he joined a circle of Netherlandish expatriate artists and intellectuals which included the greatest of all Renaissance botanists, Carolus Clusius. The courts of Rudolf II and his father, Maximilian II, were also among the principal centers of sixteenth-century botany.

The earliest florilegia (illustrated books of flowers) were published during the late sixteenth century in response to this burgeoning interest in floriculture. Unlike the botanical encyclopedia of which it was an outgrowth, the florilegium eschewed text, with the occasional exception of nomenclature. Besides offering visual delectation, such books often served ancillary purposes. The earliest printed florilegium, that of Adriaen Collaert, published in Antwerp around 1590, has small, generalized illustrations and might have been used as a pattern book for embroidery. Florilegia also advertised the wares of flower dealers like Emanuel Sweerts, whose volume, which appeared in 1612, is one of several major florilegia published in Frankfurt. Sweerts, a former prefect of the imperial gardens in Prague, dedicated his florilegium to Emperor Rudolf II, whom he described as "the greatest, most enthusiastic admirer" of flowers in the world. As is clearly indicated by Sweerts's publication, perishable flowers had come to be regarded as precious objects and hence as emblems of princely splendor.

Besides flowers, Hoefnagel depicted a host of other *naturalia* such as shells, insects, fruits, nuts, and small animals. These otherwise disparate specimens are uniformly minute, a quality that immediately invites close visual scrutiny. Such scrutiny is facilitated by the manner in which the specimens were painted. In the first place, all of them are brightly illuminated and vividly colored. Hoefnagel's images do not permit superficial scanning but rather draw the eye ineluctably to detail and ultimately into nature's recesses: to look is to participate in the artist's own process of visual investigation.

Hoefnagel's project can be connected with the much more generalized attempt to amass and array natural knowledge found in the Rudolfine *Kunstkammer*, with its display of bones, shells, nuts, fossils, and other natural specimens. His manuscript would have supplemented this extensive, if haphazard, collection just as the other compendia of hand-painted natural history illustrations kept in the *Kunstkammer* would have. Hoefnagel's images not only collect and classify nature; they also investigate its underlying structure. Accordingly, the surfaces of natural elements are consistently peeled

away to reveal their hidden internal fabrics in minuscule detail. Hoefnagel rediscovered the latent strangeness of quotidian objects such as a walnut (fol. 74), which displays its contents as if revealing occult secrets. Pears and other familiar fruits shown from odd angles (fols. 43, 51) take on an aura of the exceptional. Such commonplaces made to seem extraordinary appear alongside true aberrations and exotica such as a rhinoceros beetle (fol. 43). To peruse Hoefnagel's imagery is to embark on an optical voyage into uncharted terrain.

The central problem occupying manuscript illuminators from the early fifteenth century on was the tension between the two-dimensional page and the three-dimensional image, which intensified as manuscript illumination became increasingly spatial in imitation of large-scale painting. The page surface was thus called on to serve two functions simultaneously: as a planar support for writing and as a picture frame opening into depth. The structure thus created was weighted in favor of the script, which remained the focal point, with the narrative receding behind it and the border illuminations surrounding it. This structure was emphasized by the usual procedure of first inscribing and then illuminating a manuscript, a practice that in essence required that the imagery accommodate itself to the writing. Due to these and other factors, imagery grew increasingly competitive with script, occupying a growing proportion of the page in relation to it but at the same time never actually questioning its priority.

Until Hoefnagel, that is – for in the *Model Book of Calligraphy* his illuminations challenge the supremacy of the words. The most fundamental reversal of the traditional relation between text and image was his refusal to permit the imagery to imitate textual narrative. As long as imagery imitated narrative, the priority of the text was insured, since the implication of this relationship was that figural imagery could never fully capture invisible language. Instead, Hoefnagel imitated words themselves, turning them into objects and thereby reversing the basic terms of the earlier relationship by privileging vision. In so doing, he asserted that visual rather than verbal mimesis was the prime and superior form of imitation.

Hoefnagel's illuminations imitate Bocskay's writing not only through their confinement to the script column but also through the calligraphic flow of their forms (fol. 94). On occasion, the shapes of the specimens may even echo the accompanying script form, as on folio 16, which juxtaposes peas and beadlike flourishes in the writing. The left-to-right flow of these compositions causes them to "read" like script. Just as the imagery interlocks with the script in a continuation of its planar expanse, so the forms interlock with one another. Indeed, they seem to have been chosen largely for their capacity to fit together like pieces of a puzzle. Hoefnagel strove continually to make the viewer aware of the stationary and hence lifeless character of words in comparison to images.

The competitive tone of the model book as a whole is determined by Bocskay's extroverted display of calligraphic virtuosity. Hoefnagel's answer to this self-assured (in its creator's eyes, no doubt consummate) performance was to challenge it from within – by pitting visual imagery, with its attendant mimetic capacities, against the visual power of words – and from without – by aggressively flaunting the capacity of figural imagery to imitate nature. This is evident in the use of bright and sometimes jarring color. Folio 13, for example, juxtaposes orange-brown medlars, a fuchsia anemone, and an orange-green pear, while a highly saturated red poppy anemone dominates folio 30. The assault on visual perception is reinforced by the spatial assertiveness of the natural elements, such as the lily, pomegranate, and rhinoceros beetle on folio 43 or the pomegranate blossom, earthworm, and peach on folio 83, all of which have emphatically inflated appearances.

Hoefnagel's emphasis on looking implies that sight is a more direct and hence superior method of investigating the natural world than reading, an implication strengthened by the non-referential character of the images. With the exception of several of the black folios, they apparently bear neither a symbolic relation to the script samples nor any further iconographical significance. Sight, then, is treated not just as a medium to guide one to verbal truth but as an autonomous form of knowledge.

While Hoefnagel's illuminations aid us in comprehending the centrality of the study of nature at the Rudolfine court, they are more interesting still for what they reveal of the force of images in that milieu. His imagery insists that by virtue of mimesis, pictures claim nature's own power to confront the individual directly and so to inspire revelation. Existing like apparitions on white vellum, the images simultaneously convey the magical power involved in confronting nature and the magic of artistic creation. More than the mimicking of the serifs and flourishes of script, or the clever structuring of the page surfaces, it is the unsettling intensity with which nature confronts the viewer that poses the most profound challenge to Bocskay's script in the Getty codex. Hoefnagel asserted that images, like nature, are the sources of human experience at its most profound level, from which the written word remains ever at a remove.

The identifications of specimens proceed from top to bottom and left to right.

Common names have been provided wherever possible. In the case of the insect identifications, British English common names have been used, since most of the specimens represented do not exist in the United States. Where a different American common name is known, it has been included following the British name, separated by a slash.

The names of higher taxonomic groups (families and orders) have been printed in roman type, while genus and species names appear in italics.

Frontispiece. *Folio 52* Italic script
Castanea sativa Mill.: Spanish chestnut
Iris latifolia Mill.: English iris
Corylus avellana L.: European filbert

Folio 1 Rotunda script in "traced letters"
Vinca minor L.: Common periwinkle
Malus domestica Borkh.: Common apple
Lacerta (?): Lizard

Folio 5 Antiqua script
Matthiola incana (L.) R. Br.: Gillyflower
Ephemeroptera: Mayfly
Diptera Cyclorrhapha Heleomyzidae (?): Fly
Pulmonata Helicidae *Cepaea* sp.: Garden snail

Folio 6 Rotunda script
Lepidoptera Noctuidae (?): Caterpillar of owlet moth
Erythronium dens-canis L. "Candidum": White dog-tooth violet
Anacyclus pyrethrum (L.) Link
Pyrus communis L.: Common pear, gourd type
Prunus armeniaca L.: Apricot

Folio 10 "Sloped" Roman script
Odonata Zygoptera: Damselfly
Rosa gallica L.: French rose, pink, semidouble
Castanea sativa Mill.: Spanish chestnut
Arachnida Araneae: Spider

Folio 12 Italic script
Hymenopteran insect (?)
Narcissus pseudonarcissus L.: Daffodil
Aquilegia vulgaris L.: European columbine
Quercus robur L.: English oak

Folio 13 Italic script, widely spaced with flourishes
Mespilus germanica L.: Medlar
Anemone coronaria L.: Poppy anemone
Pyrus communis L.: Common pear, gourd type

Folio 15 Calligram: condensed Gothic script
 in the form of a chalice
Muscari botryoides (L.) Mill.: Common grape hyacinth
 (growth habit unusual)
Imaginary wasplike insect
Rosa rubiginosa L.: Eglantine
Rosa foetida J. Herrm.: Austrian brier
Lepidoptera Geometridae *Abraxas grossulariata* (L.): Magpie moth

Folio 16 Humanist Roman script with flourishes and
 interlinear ornament
Lepidoptera Satyridae *Pararge aegeria* (L.): Speckled wood
Borago officinalis L.: Common borage or talewort
Pisum sativum L.: Garden pea
Physalis alkekengi L.: Lantern plant

Folio 18 Italic script
Malus domestica Borkh.: Common apple

Viola tricolor L.: European wild pansy
Corylus maxima Mill.: Giant filbert

Folio 20 Florid Gothic script
Viola odorata L.: Sweet violet
Spartium junceum L.: Spanish broom

Folio 21 Florid script apparently inspired by a mercantile hand
Dianthus sp. (petals fringed on all sides, not just at tip, as is usual)
Prunus dulcis (Mill.) D.A. Webb: Almond

Folio 23 Florid capital Gothic script
Tulipa gesneriana L.: Tulip, pink
Hymenoptera Ichneumonidae: Ichneumonfly (inaccurate;
 Ephialtes sp. apparently served as model)
Tulipa gesneriana L.: Tulip, striped yellow, blue and pink
Phaseolus vulgaris L.: Kidney bean
Phaseolus coccineus L.: Scarlet runner bean
 or *lunatus* L.: Sieva bean

Folio 28 Gothic script of bastard type
Aquilegia vulgaris L.: European columbine
Aquilegia vulgaris L. "Multiplex": Double European columbine
Prunus avium (L.) L.: Sweet cherry

Folio 30 Hybrid minuscule script
Satureja acinos (L.) Scheele: Basil thyme
Anemone coronaria L. "Plena": Double poppy anemone
Myrtus communis L.: Myrtle

Folio 32 Italian Gothic majuscule script
Mirabilis jalapa L.: Four-o'clock, pink and yellow
Lepidoptera Lycaenidae *Thecla betulae* (L.): Brown hairstreak
Geranium robertianum L.: Herb robert
Cantherellus cibarius Fr.: Chanterelle

Folio 39 Hybrid minuscule script
Anemone coronaria L.: Poppy anemone, two flowers
Lepidoptera: Unidentifiable caterpillar
Ficus carica L.: Common fig
Cydonia oblonga Mill.: Common quince

Folio 43 Chancery script with "cut letters" (*lettere tagliate*)
Lilium chalcedonicum L.: Scarlet Turk's cap
Coleoptera Scarabaeidae *Oryctes nasicornis* (L.): Common
 rhinoceros beetle
Punica granatum L.: Pomegranate

Folio 46 Gothic script in "traced letters"
Arachnida Araneae: Spider
Prunus avium (L.) L.: Sweet cherry
Quercus robur L. with galls of Hymenoptera Cynipidae *Cynips
 quercusfolii* L. and *Neuroterus quercusbaccarum* (L.): English oak,
 leaf with cherry-galls (three big galls) and spangle-galls (two
 small galls)

Folio 47 Roman "traced" capitals
Lepidoptera Nymphalidae *Issoria lathonia* (L.): Queen of Spain
 fritillary
Malus domestica Borkh.: Common apple
Mouse
Omphalodes verna Moench: Creeping forget-me-not

Folio 51 *Antiqua* script
Lepidoptera: Unidentifiable caterpillar
Pyrus communis L.: Common pear
Tulipa gesneriana L.: Tulip, pink, bordered white
Prosobranchia Muricidae *Murex brandaris* (*L.*): Purple snail

Folio 53 Reversed Roman capitals
Consolida ambigua (L.) P.W. Ball & Heyw.: Rocket larkspur

Tulipa gesneriana L.: Tulip, yellow
Consolida ambigua (L.) P.W. Ball & Heyw.: Rocket larkspur
Arachnida Scorpiones: Scorpion
Diploda: Millipede
Corylus avellana L.: European filbert

Folio 65 Backwards slanting italic script
Odonata Zygoptera Lestidae (?): *Lestes*-like damselfly
Iris xiphium L.: Spanish iris
Odonata Zygoptera Coenagrionidae (?): *Coenagrion*-like damselfly
Ornithogalum umbellatum L.: Star-of-Bethlehem

Folio 66 Italic mirror writing
Pulmonata Helicidae *Arianta arbustorum* (L.) (?): Terrestrial mollusk
Anemone coronaria L.: Poppy anemone
Diptera Tipulidae: Crane fly (?)

Folio 69 Greek capitals and lower-case
Papaver somniferum L.: Opium poppy
Silene vulgaris (Moench) Garcke: Bladder campion
Vicia faba L.: Broad bean

Folio 70 Hebrew and Greek scripts
Leucojum vernum L.: Spring snowflake
Hyla arborea: Common tree frog
Cheiranthus cheiri L.: Wallflower
Prosobranchia Nassidae *Nassarius circumcinctus* (A. Adams) (?):
 Marine mollusk

Folio 74 Italic script
Odonata Zygoptera: Imaginary damselfly
Dianthus caryophyllus L.: Carnation
Imaginary insect
Lepidoptera: Unidentifiable caterpillar
Coleoptera Coccinellidae *Adalia bipunctata* (L.): Two-spot
 ladybird/two-spotted lady beetle

Juglans regia L.: English walnut
Prosobranchia Naticidae *Naticarius millepunctatus* (Lamarck):
 Marine mollusk

Folio 76 Italic script
Odonata Anisoptera Aeshnidae *Aeshna* sp.: Dragonfly
Pyrus communis L.: Common pear
Dianthus caryophyllus L.: Carnation
Hymenoptera Ichneumonidae: Imaginary "hymenopterous"
 "ichneumonfly⁄type" insect

Folio 81 Bastard script in "traced letters" filled with colored dots
Imaginary insect (elements of butterfly, moth)
Crataegus monogyna Jacq.: English hawthorn
Lepidoptera: Unidentifiable caterpillar
Corylus avellana L.: European filbert, fruits grown together

Folio 83 *Antiqua* script with florid interlinear ornament
Punica granatum L.: Pomegranate
Worm
Prunus persica (L.) Batsch: Peach

Folio 85 *Fraktur* script (top) and humanist minuscule with
 flourishes (bottom)
LEFT ARRANGEMENT
Lilium candidum L.: Madonna lily
Aquilegia vulgaris L.: European columbine
Tulipa gesneriana L.: Tulip, white and pink
Rosa centifolia L.: Cabbage rose
Lepidoptera: Unidentifiable butterfly
CENTRE
Peacock
Unidentifiable dragonfly⁄type insect
RIGHT ARRANGEMENT
Lilium bulbiferum L.: Orange lily

Tulipa gesneriana L.: Tulips, red, brown and yellow
Viola tricolor L.: European wild pansy
Rosa gallica L.: French rose
Anemone coronaria L.: Poppy anemone
Aquilegia vulgaris L.: European columbine
Lepidoptera: Unidentifiable butterfly

Folio 86 Fraktur script
The Burning of Troy

Folio 92 Italic script with ligatures
Unidentifiable insect
Lilium bulbiferum L.: Orange lily
Imaginary mayfly-type insect
Lepidoptera: Unidentifiable caterpillar
Malus domestica Borkh.: Common apple
Diptera Tabanidae: Horse fly

Folio 94 Italic script
Hyacinthus orientalis L. (?): Hyacinth, white bud
Morus nigra L.: Black mulberry
Lepidoptera: Unidentifiable caterpillar

Folio 102 Gothic script with ornamented initial
Lilium martagon L.: Martagon lily
Lycopersicon esculentum Mill.: Tomato

Folio 106 Diminishing writing
A Sloth (?)

Folio 112 Fraktur script with ornamented initials
Lepidoptera Pieridae: Imaginary butterfly (based on
 Pieris or related species [white])
Prunus avium (L.) L.: Sweet cherry
Pulmonata Helicidae: Two imaginary land snails (derived from
 Cepaea sp. [?])